IMAGES
of America
GEORGE COUNTY

Bailey's Scratching Post is a historic conversation piece in Lucedale. Before 1938, it was located in front of P.P. Bailey Sr.'s insurance office and inscribed with "insure a comfortable back." Afterward, its new location outside the Coffee Pot restaurant on Main Street attracted celebrity passersby, among them Dizzy Dean, Ronald Reagan, and Tennessee Ernie Ford. (Courtesy of Lucedale City Hall.)

ON THE COVER: Luce Farms produced meat and vegetables to help supply the modern canning plant built by its parent company, K-C Lumber Company, in part to provide employment for K-C employees as the timber industry waned in the early 1900s. Owner Gregory M. Luce and other company officials pose at the vat where cattle are being dipped to clean and protect them from insects. The image exhibits the husbandry of the company in all enterprises undertaken. (Courtesy of Century Bank.)

IMAGES
of America

GEORGE COUNTY

George County Chamber of Commerce
Heritage & Cultural Committee

ARCADIA
PUBLISHING

Copyright © 2018 by George County Chamber of Commerce Heritage & Cultural Committee
ISBN 978-1-4671-2906-0

Published by Arcadia Publishing
Charleston, South Carolina

Printed in the United States of America

Library of Congress Control Number: 2017960086

For all general information, please contact Arcadia Publishing:
Telephone 843-853-2070
Fax 843-853-0044
E-mail sales@arcadiapublishing.com
For customer service and orders:
Toll-Free 1-888-313-2665

Visit us on the Internet at www.arcadiapublishing.com

The authors dedicate this work to the people whose picture may never have been taken toiling in the forests, fields, businesses, and homes of George County—those who taught and served in the churches and schools and coached on sand lots, courts, and fields; the officials who endured the boredom of sitting through meetings, hearings, and discord in public office; and blue-collar workers, soldiers, lawmen, nurses, and sanitary personnel whose work is dirty and where God is most often found.

CONTENTS

Acknowledgments	6
Introduction	7
1. Native Americans and Settlers	9
2. Turpentine and Timber	17
3. Churches and Schools	29
4. Transportation and Infrastructure	47
5. Agriculture and Commerce	61
6. Medicine in George County	81
7. Law and Government	91
8. Athletics	101
9. Military	111
10. Community Enrichment	119

Acknowledgments

This publication is the debut project of the George County Chamber of Commerce Heritage & Cultural Committee. Inspiration for the work came from a publication about our county seat, Lucedale, by Dayton Whites and Roy Grafe entitled *Best Little Town*. Whites and Grafe have graciously provided text for this work as well. Readers of *Best Little Town* persisted with broader questions about George County, and this work aims to satiate their craving for more information.

Wayne Brown and Jim Yonge led the Heritage & Cultural Committee in securing photographs and authoring text. Lamar Neal provided research assistance and served as an editor and author. Tom Bailey wrote the military chapter, and Annie Ruth Thigpen, assisted by Jan Hilbun, Dana Nelson, and Patsy Horn, wrote the schools and churches chapter. Thigpen also served as hostess to the monthly committee meetings at the First Presbyterian Church. Richmond McKay led the work on the community enrichment chapter and serves the committee as a representative of the Friends of the Library. Cindy Morgan hosted workshops in the library and assisted in preparing the final copy. Many others contributed with writing, research, and gathering of information. Of special note are Nancy Jo Maples, Mark Maples, state representative Doug McLeod, Lucedale city clerk Kathy Johnson-Anderson, and Brian Nash.

The search for historic images was based in John Sims Studio, led by Kim Brannan. Sims helped initiate the work, stating "the County has a rich heritage that needs to be documented for current and future generations."

Special thanks go to Monica Turner, chamber executive secretary, for her technical leadership and special encouragement. Her ability to channel the images and written content into the prescribed layout and assist the authors was critical.

Images credited to deceased photographer George McDavid came from two albums found in a yard sale and passed along to Jim Yonge by Diane Davis. Century Bank provided images and historical information on the immense contributions of the Luce family to the county.

Harvell Jackson's *By Living Waters* and the Friends of the Library title *George County Revisited* were regular references, as was *I Remember Shipman* by Carrie Moffett.

Special appreciation goes to the many individuals who provided photographs and shared historical information with the committee. Your contributions enriched the effort and will be contributed to a museum currently in the planning stages by our committee. Much of the material gathered that did not meet the technical requirements and space for this work will be preserved in the museum.

INTRODUCTION

The history of George County is relatively short, as it was formed in 1910 from the southern lands of Greene County (formed in 1811) and the northern lands of Jackson County (formed in 1812). Lucedale, the only incorporated city in the county, was formed in 1901. The county is named after James Z. George, a US senator from Mississippi, and the city is named after Gregory M. Luce, an industrialist and community leader.

The area was mostly unsettled except along the rivers until the late 1800s. The original seat of Jackson County was in the Old Americus community. The burning of the courthouse in 1837, allegedly by the outlaws James Copeland and Gale Wages, was a primary reason the county seat was moved to Scranton, now Pascagoula. This enhanced the need for convenient local government service and thus led to the establishment of George County.

The Mobile, Jackson & Kansas City Railroad was constructed through what is now Lucedale to the head of the Pascagoula River, formed by the confluence of the Leaf and Chickasawhay Rivers. The place was named Merrill in honor of Col. Frank B. Merrill, who was president of the railroad. Ransom C. Luce helped to finance the railroad in the area. His son Gregory M. Luce established a mercantile store, built a sawmill, and served as postmaster at Plum Bluff on the Pascagoula River. He expanded the forest industry by using steamships to transport turpentine and lumber to market and continued the expansion of railroads in the county. He began his business with a $20,000 grant from the family business, Luce Furniture Company of Grand Rapids, Michigan.

The railroad provided the means for getting logs out of the swamps and off the hills and shipped to market. Sawmills, depots, churches, one-room schools, country stores, and related businesses were established in communities that formed along the railroads. It is recorded that in 1915 there was a sawmill every 15 miles on every road in the county in addition to the large mills of K-C Lumber Company near Lucedale, where all roads led. This is how the communities of Agricola, Basin, Bexley, Broom, Evanston, Lucedale, Rocky Creek, Shipman, and others came into existence.

The establishment of the town of Lucedale in 1901 and George County in 1910 are the most important events in the history of the county, as they provided the hub for community and economic development. The intrinsic wealth of the soil and water resources, available capital, labor, and visionary management provided the means for developing sustainable agriculture and commerce.

K-C Lumber Company continued to capitalize development in the county by establishing agricultural enterprises and building a canning plant, providing employment for workers as the timber industry waned. Gregory Luce organized the Bank of Lucedale in 1903 and served as president. He assembled a board of directors from professionals and business leaders who helped capitalize and influence the bank's integrity. While many banks in the country failed during the Great Depression, the Bank of Lucedale remained solvent.

County residents endured the hardships of the Great Depression better than many areas because of the developing agricultural base and the abundant natural resources in the area. The canning

plant stayed open, even though prices tumbled, until it was completely destroyed by fire in 1934. It was rebuilt the same year and operated until World War II.

Churches provided the spiritual and cultural base for the communities and neighborhoods in the county. Many of the churches originally had one-room schools. The small schools were consolidated into six white schools, Agricola, Basin, Broome, Central, Lucedale, and Rocky Creek, and the "colored school." The high schools were consolidated in 1964, and the system was integrated in 1968. The elementary schools remain in the communities. The school board, chaired by Virdie Brannan, wisely appointed Leander Taylor, former principal of the colored school, to oversee the federal funding of the system. The exciting play of the integrated athletic teams is credited with easing racial tensions created during the integration process. The school colors are maroon from Mississippi State University and gold from the University of Southern Mississippi. The mascot is the Rebels from the University of Mississippi. Citizens organized to pass a bond issue for the building of a new, modern high school and have since voted to maintain the level of funding, upgrading the safety, technology, vocational, and construction needs of the growing school system.

The greatest natural disasters in the county have been hurricanes and their resulting floods. The earliest hurricane recorded in the county was in 1916. The flooding in Merrill heavily damaged the town, and timber destruction was immense. Logs were cut and stored in ponds in hope of future use. Hurricanes Camille, Frederic, Elena, Ivan, and Katrina have struck the county in more recent years, resulting in power outage, downed timber, limited structural damage, flooding, and debris. The resilient citizens have repaired, rebuilt, and strengthened to better endure the next hurricane.

Climate in the county is among the most favorable in the country. The growing season allows for double cropping of the rich silt loam soils. Numerous species of nursery stock survive the mild winters to grow into larger and more profitable plants. Pres. Woodrow Wilson recreated in the area in 1916 and credited his refreshment to the quality of the environment.

George County has benefited over time from the employment opportunities and recreation in the nearby coastal cities. The county has been described as a bedroom community for the coast. Boating and saltwater fishing lure county residents to the coast, while hunting and freshwater fishing lure coastal residents to George County.

The Pascagoula River basin is a prized and valued asset of the county. It is formed by the confluence of the Leaf and Chickasawhay at Merrill and is the longest unimpeded river in the United States. The basin is in a migratory flyway, and thousands of acres have been wisely preserved in George County to provide a primary landing area for migrating birds and waterfowl when they complete their trip across the Gulf and prepare for further flights north. It is home to the Mississippi kite and leads to spawning areas for the gulf sturgeon in the Chickasawhay River.

George County has a proud history of military service. Residents of the area have been involved in all American wars and conflicts—the Revolutionary War, the War of 1812, the Civil War, World Wars I and II, Korea and Vietnam, and the ongoing war on terrorism. George County has one Medal of Honor winner, Jake Lindsey, and several Silver Star winners. George County citizens have always been ready to help defend our great land.

The county and city are relatively young, but the land and people who earlier invested capital and labored in family, farm, business, and infrastructure developed the culture that makes George County special. Hopefully this presentation will document their efforts and help inspire current and future generations to build on our rich heritage.

One
NATIVE AMERICANS AND SETTLERS

Warm southern breezes, abundant wildlife, fertile soil, and fish-filled streams made the land that would become George County habitable and attractive. Signs of early Native American presence have been found throughout the county. The resources that attracted Native Americans also attracted early settlers and continue to draw new residents.

The flags of five nations have flown over the land that constitutes George County. The area was first claimed by Spanish explorer Ponce de Leon in 1516 and Hernando de Soto in 1538. Robert de La Salle claimed the area for France in 1682, but at the close of the French and Indian War, Great Britain received the territory. In 1779, Great Britain ceded the territory to Spain during the Revolutionary War. The United States of America received the land from Spain in 1795 by the Treaty of San Lorenzo. The state joined the Confederates States of America during the American Civil War.

Roads and railroads were built in the late 1800s and early 1900s to transport the harvest from the region's abundant virgin timber. These roads and railroads promoted commerce by connecting cities and ports. The rich loamy soil of the cut-over timberlands proved ideal for farming and drew new residents into the area.

Routine flooding of the Pascagoula River basin, especially in the town of Merrill at the headwaters of the Pascagoula River, drove the residents from the river basin to higher ground. Many moved to the new town of Lucedale along the railroad. The town, named in honor of Gregory M. Luce, was incorporated on June 6, 1901, within the former boundaries of Greene County, Mississippi.

On March 16, 1910, George County was formed from the southern 151 square miles of Greene County and the northern 333 square miles of Jackson County. The county was named in honor of James Z. George, a US senator for Mississippi from 1881 until 1887. Lucedale became the county seat and the only incorporated town in George County.

Rawleen Counselman Knowles displays extensive Native American artifacts that her family found on their farm in George County. The numerous streams, bountiful wild game, mild climate, productive and well-drained soil, and ample food sources all combined to make the area ideal for human habitation. Native Americans ranged all over the area, especially near streams that provided water, fish, and transportation. (Courtesy of Jim Yonge.)

In 1901, the new town of Lucedale was named after G.M. Luce, who was initially involved in timber harvesting. He saw a bright future beyond timber, which led him to invest his capital in manufacturing, retail, banking, railroads, shipping, and other ventures. His conservative leadership assured a positive future for Lucedale and George County. (Courtesy of Century Bank.)

Jim Yonge portrays G.M. Luce at the centennial celebration of George County. Luce was a pioneer in the development of the county and Lucedale. The town was named in honor of this visionary businessman. (Courtesy of George County Board of Supervisors.)

Merrill, Mississippi, was named after Col. Frank B. Merrill, who sponsored the construction of the Mobile, Jackson & Kansas City (MJ&KC) Railroad from Mobile, Alabama, to the Pascagoula River just below the confluence of the Leaf and Chickasawhay Rivers. The town of Merrill thrived due to timber being transported over water to the mills and railroad. This house reflects the strong economy of Merrill before the town was diminished by periodic flooding. (Courtesy of Diana Hobby Knight.)

A donkey and a dog take refuge at this house in Merrill from the flooding of the adjacent Pascagoula River. Periodic flooding doomed the once-prosperous town as residents moved to higher ground, especially to the newly formed Lucedale on the railroad well above flood stage. Merrill suffered severe floods in 1900, 1905, 1906, 1910, and the July storm (hurricane) in 1916. (Courtesy of Diana Hobby Knight.)

The south side of Main Street in Lucedale is seen looking west at a point east of Mill Street. The two-story building with the porches in the background is the Brewton building and medical office. The children posing on the fence are unidentified. The photograph was taken around 1915. (Courtesy of John Sims Studio.)

COURT HOUSE. LUCEDALE, MISS.

The George County Courthouse was constructed in 1910–1911 and completed in October 1911. The courthouse cost less than the $40,000 that had been appropriated, and provided county government within a day's wagon ride of most citizens, except those living west of the Pascagoula River. It has undergone additions and renovations since its dedication in 1911. (Courtesy of John Sims Studio.)

This aerial view shows Lucedale looking southeast across Main Street (Highway 98), with Lamar Street in the foreground perpendicular to Main Street. Fails Funeral Home, now Sigler Funeral Home, is in the foreground, and the T.H. Byrd home is just across Lamar Street, fronting on Main Street. Winter Street is near the center and is perpendicular to Main Street. This view is from the 1940s, before the construction of the George Regional Hospital. The cupola of the courthouse is at top left. The residence at bottom left was the home of Claude Passeau and later Dr. Raymond Tipton. (Courtesy of the *George County Times*.)

George County officials pose with Sen. Thad Cochran on the steps of the George County Courthouse at the 2010 centennial celebration of the county dressed in 1910 fashion. From left to right are (first row) Henry Cochran, District Five supervisor; Cammie Brannon Byrd, chancery clerk; Sue Cochran, District Three supervisor; and Kelly Wright, District Two supervisor; (second row) Wilburn Bolen, tax assessor; Fred Croom, District One supervisor; and Chad Welford, circuit clerk; (third row) Garry Welford, sheriff; Senator Cochran; and Larry Havard, District Four supervisor. (Courtesy of the George County Board of Supervisors.)

Two

Turpentine and Timber

George County is in the pine belt, which reaches from the Carolinas to Texas. A full fire-resistant canopy of longleaf pines that produced turpentine covered the uplands. The bottomland produced hardwoods and slash pines that also produced turpentine. Distilled turpentine produced cleaning spirits, resin, and tar used in the making of paper and in ships and buildings.

The buoyant pine logs were floated down the river to sawmills beginning in the late 1860s. Construction of the MJ&KC Railroad through the county to Merrill made the river town the center of commerce until the flood of 1916 sealed its fate in favor of Lucedale.

Sawmills and short-line railroads from the main MJ&KC line were built at Latonia, Shipman, Rocky Creek, Bexley, and Merrill.

Logging on the Escatawpa River began with floating the logs to mills in Moss Point. Howells Ferry was the early center of operations in what was called Brushy before 1900. The Howell, Shipman, Agricola, and Brushy Creek communities bordering the Escatawpa River were in Brushy.

Ransom Luce & Sons secured lands bordering the Pascagoula River in 1889 and opened a large mercantile store and steamship line at Plum Bluff managed by Gregory M. Luce. The company rafted logs and provided a market for area turpentine producers by shipping it downriver to Pascagoula. The company built a railroad toward Lucedale, where other properties were secured. K-C Lumber Company was incorporated in 1902. The company built a sawmill east of Lucedale capable of producing 80,000 board feet of lumber per day.

Small towns grew along the railroads, supported first by turpentine stills and sawmills. As the timber was harvested, farmers prospered on the fertile soils. Automation and improved roads made it convenient for residents to bypass the small towns in favor of Lucedale and the coastal cities.

Turpentine continued to be harvested from second-growth pines, mostly on land not suitable for farming and under government regulations beginning in 1923. Paper mills provided a market for pulpwood haulers in the county. The mills bought large tracts for reforestation to supply pulpwood.

Turpentine workers for Charles G. Steede (far right) and Willie Steede (left) are shown with axes used to chop boxes in virgin pine trees. The Steede farm provided housing for the crew that worked on the farm and in the turpentine still year-round. (Courtesy of C.G. Steede.)

This pine tree, located in the Pascagoula swamp near the Pree Eddy Lake, is alive at this writing. It has an original chop box face and a cup face, revealing the ability of the pine tree to survive the injury from turpentine harvest. (Courtesy of Jim Yonge.)

This turpentine face is from 1960, with an aluminum cup. Earlier cups were made of clay or steel. Each face was chipped every two weeks and dipped once a month from April to October. Three hundred cups would fill a 50-gallon drum that sold for $35 in 1964. (Courtesy of Jim Yonge.)

Logging for timber was confined to forests near the rivers after the Civil War and before railroads. Loggers would place logs on sandbars in dry weather and prepare them to be floated downriver at flood stage. The float from Merrill to Moss Point took six days and nights nonstop. The loggers were met with mules and wagons to return home with money and supplies. (Courtesy of Century Bank.)

Mules and rollers were used to move logs short distances to the rivers and later to the railroads. The roller was placed under the large end of logs, making them easy to pull. The forest industry provided employment for many freed slaves and their children. (Courtesy of Century Bank.)

Skidders pulled by oxen were the primary means of moving logs to railroad loading areas. The large wheels on the skidder were more effective in swamps and muddy areas, and oxen were better foragers in the forest than mules. (Courtesy of Century Bank.)

The eight-wheel Lindsey wagon pulled by teams of oxen became popular as a means to transport logs greater distances to the rivers, to railroads, and to growing numbers of local mills along the railroads. They were replaced by trucks in the early 1900s. (Courtesy of Sandra Reeves.)

Trains were the ultimate transporters of logs, including hardwoods from the swamps. Pine was the only log used in floating because it was lighter, easier to cut, and floated when green. Railroad spurs called dummy lines were built from the main line to access remote areas. (Courtesy of Century Bank.)

The steamship *Alice*, property of Luce & Sons, is shown loaded with turpentine at Plum Bluff for transporting to markets on the coast. It brought back stock for the huge mercantile store shown. The shipping provided a market for area turpentine stills. (Courtesy of Century Bank.)

Exterior building materials included shingles, shakes, boards, and batting. Cypress was the favored wood for shingles, as it was light, easy to split, and weathered well. This mill, operated by K-C Lumber Company, cut building material for the area. (Courtesy of Century Bank.)

K-C Lumber Company constructed this large sawmill primarily to harvest timber from the 20,000 acres of choice upland east of Lucedale where Luce Farms and a canning plant would later be located. The land was purchased from the federal government by three Northern investors before 1890. (Courtesy of John Sims Studio.)

This payroll receipt to Ash McLeod shows that he worked for K-C Lumber Company 25 days at $2.50 for $60 in March 1912. He had received an advance of $6.05 and was charged $1 for accident insurance, which left him $52.95 to take to the bank, owned primarily by the company. (Courtesy of LeBarron McLeod.)

Small, steam-powered "peckerwood" mill operators provided lumber for farm and home building needs. They were designed to be dismantled and moved when an area was cut out. Trucking to and from large mills replaced the need for small mills. (Courtesy of Jim Yonge.)

Pulpwood hauling from second- and third-generation pine timber to railroads and paper mills provided a source of income to independent haulers and fulltime employment with the mills. The federal government subsidized tree planting in the 1960s, which is available for harvest at this writing. (Courtesy of George McDavid.)

The Parker fire tower west of the Agricola community served to spot and locate forest fires in conjunction with other fire towers, making it possible to triangulate the location of the fire to accurately dispatch firefighting crews long before GPS. This old timber structure was demolished in the 1950s. (Courtesy of Benny Shows.)

This fire tower in Central was operated by the Odell Price family for over 50 years. Odell Price was employed by the Forest Service in 1940, followed by his wife, Mae, and finally by his son Jimmy until the tower was closed in 1997. (Courtesy of George McDavid.)

Members of the George County Forestry Association review the method for timber estimation per acre in 1990. Members are, from left to right, Phyllis Allen, Faye McNeil, Kerry Johnson, Russel Evans, two unidentified, Danny Box, and Monroe Mathis. (Courtesy of Mississippi State University Extension–George County.)

Dave Lollis, retired George County forester, embraces a southern magnolia in 2017 that once held the state champion title in the George County area of the Desoto National Forest. Its circumference is 15 feet, 2 inches, its height is 105 feet, and its crown spreads 75 feet. Virgin pines and hardwood trees this size were once common in the area. (Courtesy of Jim Yonge.)

Three

CHURCHES AND SCHOOLS

Settlers began migrating to what today are Jackson, George, and Greene Counties of Mississippi in the early to mid-1800s. After they cleared enough land to plant a crop and build a cabin, the next priority was a place to worship and to provide an education for their children. Transportation was limited at best, so communities formed around a general store and a church. The church or churches became the center of communities and provided not only a place of worship but also a place for fellowship, entertainment, and in many cases, education.

Many of these communities were well established before the area became George County. Rocky Creek, Agricola, Broome, Shipman, Ward, Brushy Creek, Merrill, and Lucedale were some of the major communities in the area, and the church and school were the nucleus of each.

Rocky Creek Baptist Church was organized in the mid-1800s, and the building was used as a place of worship and as a school. The one-room building was a log structure with two windows, one door, and a dirt floor. Crossroads Methodist Church in the Central community was organized in 1826, and, like Rocky Creek, it served as a church and school. Antioch Methodist Church, located in the Broome community, is one of the oldest churches and was organized in 1825.

As the communities began to grow, one-room schoolhouses were built, and smaller schools began to merge together to better support one or more teachers. African American churches were organized throughout the county, and in many cases, those buildings also served as schools. However, educational opportunities for African American children, especially in the rural areas, were limited until the county schools were integrated in 1968.

As transportation improved, smaller schools continued to merge, and by the 1950s there were only four high schools in George County: Rocky Creek, Agricola, Broome, and Lucedale. In 1965, the four schools were consolidated into George County High School.

Howell Baptist Church was dedicated in 1908 on Howells Ferry Road near the ferry on the Escatawpa River, an early launching point for floating logs downriver to Moss Point, Mississippi. The church was relocated to its current site on Highway 612 around 1935, leaving only the graveyard at the original site. (Courtesy of Howell Baptist Church.)

Antioch United Methodist Church on Highway 57 South in Benndale was established and recognized by the conference in 1825. The first church was constructed of logs and was west of the present church. It was the first church in Benndale and was a community church. (Courtesy of Annie Ruth Thigpen.)

Shipman Methodist Church has a unique heritage. William A. Shipman moved from Georgia to Mississippi to operate a turpentine still. He moved to Brushy to build a sawmill. Community leaders planned the church building, and Shipman donated the lumber and recruited friends from Georgia to help build the church. He did the same for Mount Olive, the African American church nearby. (Courtesy of Annie Ruth Thigpen.)

This beautiful building, nestled on a sandy knoll and surrounded by stately oak trees draped with Spanish moss, served as a house of worship for the people in Merrill. Built in the early 1900s, it was used by both the Baptists and Methodists. In later years, it became the Merrill United Methodist Church. In the mid-1960s, Merrill became part of Grace United Methodist Church. (Courtesy of Carolyn Haines.)

Crossroads United Methodist Church was organized in 1826 and is one of the oldest churches in the county. The congregation is pictured with Rev. H.J. Hedgepeth, probably in the 1950s. They are standing in front of the wood-frame church that was destroyed by fire many years later. It was replaced with a beautiful brick structure. (Courtesy of Annie Ruth Thigpen.)

Pleasant Hill United Methodist Church was founded around 1878 in the Basin community. Church land was given by the J.B. Goff, William L. Harvison, and Donnie Parnell families. The first church was a small structure, followed by a larger building with a bell used to alert the community of fires and deaths. In 2017, its 139th year, Pleasant Hill continues to thrive. (Courtesy of the *George County Times*.)

Salem Campground began in 1826 on Cedar Creek in north Jackson County near what is now the George County line. Camp meetings were common at that time. Families would move to the campground and live in tents or cabins they constructed. Worship services are held morning and evening in early October each year. (Courtesy of Jim Yonge.)

This house stands on the corner of Mill and Church Streets in Lucedale. It was originally built in 1885 as the First Methodist Church. Dr. Charles E. Ward bought the building in 1911 and converted it into the family residence. Dr. Ward was the first dentist in Lucedale and the first to occupy the second story of the Main Drug Store building, owned by Dr. James Dorsett. Dr. Ward served as mayor of Lucedale during World War I and had four sons serve during the war. The house remains in the family and is currently owned by Erik Ward, a great-grandson of Dr. Ward. (Courtesy of Jim Yonge.)

Lucedale United Methodist Church was founded in 1899. This building was completed in 1909 on Main Street. In 1921, fourteen classrooms were added to the rear of the sanctuary. These rooms were later torn down and new ones constructed. The facility now has a modern family life center. (Courtesy of Jim Yonge.)

Lucedale Baptist Church was founded in 1902. Services were held once a month in the Masonic hall until 1906. After additional lots were purchased, the church was rebuilt on Summer Street. That building was destroyed by a storm in 1916. This Gothic-style building was constructed in 1946. The church was renamed First Baptist Church of Lucedale in 1958. (Courtesy of Jim Yonge.)

Barton Baptist Church, on Highway 63 south of Lucedale, was organized on October 22, 1933, at Sam Dungan's home. Services were held in various locations before the church was built on land donated by John Havard. The parsonage was built beside the church. Standing by the parsonage is pastor Rev. F.E. Runyan and his wife, Libby. (Courtesy of Elsie Harvey.)

Mount Olive Missionary Baptist Church in Shipman was organized in 1898 under the leadership of Rev. Dave Cook. A plot of land was purchased from M.M. Phipps, and a building was erected. Because of a shift in population and bad roads, land was purchased from James Talbert Jr., and a new building was constructed. The church is on a sandy knoll near the railroad in the Shipman community. (Courtesy of Annie Ruth Thigpen.)

Union Missionary Baptist Church began near the turn of the 20th century as a brush arbor at Charlie Mallette's home. Named Union Church because many denominations met there on the weekends, the present church was established on May 3, 1913, on land donated by W.D. "Dack" Horne. In the 1930s, a hurricane demolished the building, and the existing building off Highway 613 was constructed between 1942 and 1944. (Courtesy of Jim Yonge.)

Macedonia Missionary Baptist Church is located in the Brushy Creek community. It was organized in 1879. Three of its members, T.W. Brannan, John Whatley, and Powell Mason, paid $550 for five and a half acres. A simple wood-frame building was constructed and later replaced with a larger wood-frame building and the present facility. (Courtesy of David Short.)

Bernice Passeau requested that a priest come from Mobile to hold services in her home prior to St. Lucy's Catholic Church's establishment in the early 1950s. Built on Mill Street and dedicated on March 18, 1951, the parish remained there until this new church on Scott Road, with an education center, was dedicated on September 28, 1986. (Courtesy of Josie Henderson.)

First Presbyterian Church began as a mission on April 12, 1953, in the C.O. Gilbert home. Services were later moved to the American Legion hut before a dwelling house was purchased. After the church's organization in 1956, an education building was added in 1960. The fellowship hall served as the sanctuary until the current sanctuary was completed in 1990. (Courtesy of Jim Yonge.)

Rocky Creek School became the first school in the George County area in 1894. One teacher taught students in a one-room log building with a dirt floor. Rocky Creek progressed to become an accredited high school in 1927. C.A. Bryan was responsible for consolidating Davis Farm, Brannan, and Shipman Schools to form Rocky Creek Consolidated School. Today, it is Rocky Creek Elementary School. (Courtesy of John Sims Studio.)

Students are pictured at Rocky Creek High School in the early 1930s. Eula Lee Welford Hartley is seated second from left. Mae Belle Eubanks Havard is seated at far right. Merle Horn stands at far left. (Courtesy of Annie Ruth Thigpen.)

Public kindergartens became a part of the school system in 1986–1987. Kindergarten students at Rocky Creek Elementary adjusted to school life, learned their ABCs, 123s, and many other basic skills. As the school year came to a close, they presented a program to the student body and PTO based on Mother Goose and other nursery rhymes. (Courtesy of Annie Ruth Thigpen.)

Carolyn Cochran, a graduate of Lucedale High School, represented Mississippi Southern College (now the University of Southern Mississippi) in a preliminary pageant and won the title of Miss Mississippi in 1955. She was the daughter of W.O. Cochran, who served as Lucedale's mayor from 1952 to 1955. Carolyn was actively involved in the Lucedale High band as majorette and drum majorette and continued her music endeavors as a Mississippi Southern Dixie Darling. (Courtesy of Shari Mcginnis.)

Basin High School, established in 1887, was consolidated into George County High School in 1964. The elementary school students were transferred mostly to Central Elementary. The facility houses the Singing River Education Association, including Head Start. Head Start also has a facility in Benndale. (Courtesy of Elsie Harvey.)

George County schools contracted individuals in the community for student transportation. Bob Brown of Agricola used his farm truck with a homemade body. Seating consisted of four benches, one on each side and two down the middle. The bus transported students during the school year and produce to market in the summer. (Courtesy of Benny Shows.)

The Broom School was located west of the Pascagoula River in the southwest area of George County. The school was supported by prominent families and churches in the area. The elementary school and high school were consolidated in 1964. Population decreased in the area during the reforestation era. (Courtesy of the George County School District.)

Seventh-grade students from the 1925–1926 class at Agricola Elementary School pose for a class photograph. From left to right are (first row) Ernest Carr, B.R. Hattaway, John Earl Hunter, and Moliter Vise; (second row) Myra Cook, Choyce Roberts, Mary Wall, Ellis Howell, Lorene Shirey, and Lucille Hathcock. (Courtesy of Benny Shows.)

Students from the 1925–1926 class at Agricola Elementary School are pictured here from left to right: (first row) James Wood, Carl Brown, Ealy Maxwell, W.C. Dogett, Winfred Tanner, Marshall Bryant, Hervey Hunter, Hilburn Hamilton, and Marvin Bryant; (second row) Etoyle Brown, Eula M. Counselman, Macie Lee Flynt, Irene Tanner, Myrtis Churchwell, Birdie Gunter, Coyce Pierce, Tressie Pierce, Camille Sumrall, and Etta Mae Shirey; (third row) Eugenie Hathcock, Nola Brown, Marie Roberts, Guessie Pierce, Celes Vice, Johney Lee, and Elridge Tanner; (fourth row) Ola Mae Parker, Lillie Smith, Delphine Lee, Pearlie Lee, Matt Dogett, Elmore Howell, and teacher Fannie Flury. (Courtesy of Benny Shows.)

Lucedale students from the eighth grade class in 1928–1929 are pictured here, from left to right: (first row) Emily Summerour, Austeen Mallette, Dimple Byrd, Majorie Lane, Mary A. Hurst, Ouida Morgan, Inz Jaggar, Carolyn Dorsett, and Mary E. Slay; (second row) Miss Johnston, Miss Knight, Ethel Rouse, Louise Lumpkin, Gladys Ferrill, Vera Pope, Holly Gene Hart, Ethel Clark, and Julia Thomas; (third row) Ray Holder, Woodrow Reid, Wilford Collins, Deuitt Parker, Fred Tomlin, Elwood Williams, Miss Collins, and Miss Havene. (Courtesy of Annie Ruth Thigpen.)

The Bexley School building has been restored and stands today as a monument to the past. Bexley was a thriving sawmill town on the railroad during the early 1900s. One of the largest mills in the county was there, and a short-line railroad was built north toward Greene County. (Courtesy of Jan Hilbun.)

A teacher and students are gathered in front of Central Elementary School for this class picture. The year the photograph was taken is unknown. Located on Highway 26 west of Lucedale, the school was remodeled in 2002 to serve the growing population. (Courtesy of Central Elementary School.)

Oak Grove School was commonly called the county's "colored school" before integration. The school was a positive force in the development of George County. It was surrounded by homes and churches and enjoyed the service of dedicated administrators and teachers. Former teachers Myrtis Talbert and Doris Alexander are pictured with former superintendent Leander Taylor. (Courtesy of Annie Ruth Thigpen.)

County Line School was originally south of Lucedale on the Greene–Jackson County line before George County was established. It was moved to Lucedale Municipal Park by the City of Lucedale. The exterior and interior were restored and it was equipped with period furnishings by a committee of volunteers in cooperation with the city. (Courtesy of Annie Ruth Thigpen.)

The pride of the county is George County High School, formerly known as Lucedale High. The school welcomes all George County students in grades nine through 12. It is south of Lucedale on Highway 63. Students entered the new high school in the fall of 1994. Concerned citizens organized to promote the bond issue to build the facility, and again to support continued funding for needed improvements. (Courtesy of Jan Hilbun.)

Four

Transportation and Infrastructure

The first Native Americans in the George County area most likely traveled on local streams, then along game trails that were later improved by early settlers into roads with fords, bridges, and ferries. George County today is served by two major four-lane highways, a major east-west railroad, and a short-line railroad extending from George County to the Gulf Coast along with a plethora of paved roads. Airports in Mobile, Pascagoula, and Gulfport provide nearby air service. Electricity was first provided to Lucedale by a generator owned by a private company and fueled from the railroad. Mississippi Power Company acquired the system and constructed transmission lines to power the electrical needs of the growing town. Singing River Electric Power Association, now called Singing River Electric Cooperative (SRE), was formed with federal assistance and extended electrical power into all rural areas of George County by the early 1950s.

Water for residents of Lucedale was first provided by a private company using large electric-powered deep wells and an elevated steel tank. Lucedale acquired the water system and added a sewer system in the 1950s. Rural residents of George County initially acquired water from prevalent shallow aquifers by use of springs, bucket wells, hand pumps, windmills, and electric pumps. Beginning in the 1960s, the Bexley, Rocky Creek, Multi-Mart, and Combined rural water systems used federal funding to provide a dependable source of safe, clean water to most of the growing rural population east of the Pascagoula River.

George County had a limited telephone system until the early 1950s, when South Central Bell Telephone established a new system and extended telephone lines into all of the county east of the Pascagoula River. The area west of the Pascagoula River obtained telephone service in the 1960s. Today, telephone wires, wireless systems, cable, and satellite television can be found throughout the county.

George County is crisscrossed with numerous petroleum and natural gas pipelines, providing transport to ports and end users all over the United States.

The two men in the buggy are traveling with a horse for swift, safe local passage over the primitive trails and roads. Horses and wagons caused the three-path roads that were prevalent before the advent of the automobile. Note the large virgin pine trees in the background that drew so many to the George County area. (Courtesy of Century Bank.)

Two steam locomotives, with crew members, are attached to cars loaded with George County yellow pine logs destined for sawmills. These timber-gathering railroads led to the establishment of communities and the town of Lucedale in George County, resulting in a flow of passengers and commercial goods along with timber resources. This trade and commerce attracted settlers along the railroads. (Courtesy of Century Bank.)

A well-dressed crew of men lounge on the railroad track. These workmen were most likely enjoying a Sunday respite from the difficult early days of timber harvesting and railroading. Standing at far right is James Arthur Hathcock. (Courtesy of Benny Shows.)

Mississippi Export Railroad (MERR) steam locomotive No. 38 operated between Lucedale and the Moss Point–Pascagoula area. The MERR connected the Gulf Mobile & Ohio Railroad (GM&O) in George County with the Louisville & Nashville Railroad at Moss Point. These railroads served George County with product transportation to and from coastal ports and far-flung cities. (Courtesy of the MERR.)

This early photograph of Lucedale's elevated water tank was taken looking north from Main Street (US Highway 198). The house in the foreground was removed to allow for the construction of Freeland Motor Company. The water tank was placed on the highest ground in Lucedale with a ground elevation of 315 feet. The steel tank was erected on a 100-foot-tall tower to provide high pressure flow to all citizens of Lucedale. The tank served from 1908 until it was demolished in 1969 and replaced by a larger single-pedestal tank. The Lucedale Library is built on the site of the old tank. (Courtesy of Century Bank.)

Farnsworth Lumber Company workers pose on a locomotive at a lumber camp near Benndale, Mississippi, around 1915. Marcus Helverston, the train engineer, is seated on the left, and the others are unidentified. Trains transported yellow pine logs from inland forests to the Pascagoula River, where they were floated in rafts downriver to mills located in the Moss Point area. (Courtesy of the Fairley family.)

This view of the Merrill Bridge was taken from the GM&O railroad bridge over the Pascagoula River just south of where the Leaf and Chickasawhay Rivers join to form the Pascagoula. The Merrill Bridge was constructed as a toll bridge in 1927 to replace a ferry. The bridge was closed by damage from Hurricane Camille in 1969 but reopened, only to be closed by Hurricane Frederic in 1979, reopened again, and closed in 2015. (Courtesy of Century Bank.)

Three-year-old Leslie William Lassiter Jr. stands with his aunt Evelyn Frances Stringer next to a barnstorming plane in 1928. Lassiter graduated from Lucedale High School, received a degree in electrical engineering from Tulane University, and served as a naval officer during World War II. After the war, he entered a career in air transportation, and was later promoted to vice president in charge of engineering for Lockheed Aircraft Company in Marietta, Georgia. (Courtesy of Brown family.)

The Wilkerson Ferry provided passage across the Pascagoula River on State Highway 26 in west George County. The ferry operated until Highway 26 was relocated in 1950 on a more direct route from Lucedale to Wiggins, Mississippi, with a one-mile-long bridge spanning the Pascagoula River and adjacent flood plain. The operator is Travis Reeves, and Joe Mizell stands in front of his 1940 Ford sedan. (Courtesy of William and Connie Glenn Wilkerson.)

Wilkerson Ferry operator Milton Murrah is conveying a log truck belonging to Joe Davis, shown standing left of his truck. This view is from the west side of the Pascagoula River. This ferry and the Merrill Bridge provided the only means for commerce to travel between east and west George County until the new Highway 26 bridge was built. (Courtesy of William and Connie Glenn Wilkerson.)

Lucedale High School majorette Gladene Breland cuts the ribbon on the relocated and newly constructed State Highway 63 from Lucedale south to the county line. Assisting her from left to right are unidentified, supervisor W.T. "Bud" Moody, attorney M.L. Malone, highway commissioner John D. Smith, unidentified, Breland, state senator Hudie Pitts, district engineer J.F. Brownlee, supervisor W.W. "John" Cochran, unidentified, M.B. "Buster" Brown, and unidentified. (Courtesy of George McDavid.)

In 1964, George County's first Ford Mustang caused quite a stir in Lucedale and the rest of the county. From left to right are Evern Malone, unidentified, Ralph Cooley, unidentified, and salesman Ralph Fairley. This car was purchased by Richmond Mckay, who in 2017 regrets that he later sold it. (Courtesy of George McDavid.)

Bernice Woodard (left) and Ida McInnis depict the old way of using a hand water pump and a rub board for washing clothes on a float celebrating the completion of the Bexley water system, which served clear, safe, reliable, pressurized water to rural residents. Bexley, Rocky Creek, Multi-Mart, and Combined rural water systems, financed by the Federal Farmers Home Administration, replaced the need for home wells, springs, and other undependable water supplies. Bexley was the first rural water system in the United States financed by the Federal Farmers Home Administration. (Courtesy of George McDavid.)

Jim Piercy stands beside a well drilling rig he built and mounted himself. Piercy was a mechanic, craftsman, and well driller who lived for 104 years. He was known as an early innovator who drilled wells across George County and surrounding counties. The Piercy family continues in the well drilling business. (Courtesy of Ann Hollingshead Piercy.)

Without electricity, rural residents in the first half of the 20th century were unable to progress at the rate of city residents. Privately owned electric companies served only densely populated areas. Electrically operated lights, farm tools, and home appliances made life better for farmers and their families. Above, SRE workers erect poles in the early 1950s using an A-frame and winch attached to a power wagon. The power wagon was a World War II Army surplus purchase. Below, Bo Gambles poses beside an early truck at a work site during the 1950s, when he served as a lineman. Later, he was promoted to crew supervisor. Gambles worked at SRE from 1940 until 1984, excluding a 46-month stint in the US Army during World War II. (Both, courtesy of SRE.)

Serviceman Buck Strickland, later a field representative, stands beside an early 1950s SRE truck featuring the Rural Electrification Administration (REA) emblem. Franklin D. Roosevelt started the REA to provide federal loans for cooperatives to build electric lines to rural residents. (Courtesy of SRE.)

SRE is a nonprofit organization whose membership elects a board of directors from within the service territory to assist in decision-making policies and to be a voice for the people. Shown in the early 1990s are, from left to right, (first row) director G.A. "Don" Parnell, general manager Jack Ware (1980–1998), director Frank Ely, director Travis Baxter, and director Jay Henley; (second row) board attorney Mark Maples, consultant Tim Dudley (general manager, 1948–1980), director S.J. Henderson, director Tyra Byrd, director Ralph Hicks, director Roy Grafe, and director Bo Hall. (Courtesy of SRE.)

SRE serves Jackson, George, and Greene Counties as well as parts of Harrison, Perry, Stone, and Wayne Counties and parts of two Alabama counties. On August 29, 2005, Hurricane Katrina severely damaged the Mississippi Gulf Coast, including SRE's service territory. Homes were destroyed, and electric lines, like those pictured here, were downed. (Courtesy of SRE.)

After Katrina, service crews worked around the clock to restore power to members. In this photograph, SRE workers cut a tree limb off a power line near Mississippi Highway 26 in George County. Technology and tools have greatly improved during the cooperative's 80-year history. (Courtesy of SRE.)

Several sources are used to generate power for SRE's members, including natural gas, coal, nuclear, hydroelectricity, and most recently, solar. These solar panels, on old Mississippi Highway 63 south of Lucedale, are owned by Cooperative Energy, the association that generates and purchases power for SRE. Cooperative Energy is incorporating more green power resources to help protect Mississippi's environment. Maintaining a mix of diverse energy sources helps protect power availability and affordability, keeping lights on and energy bills low. (Courtesy of SRE.)

Five

Agriculture and Commerce

In 1901, Gregory Luce had the area around the K-C Lumber Company mill surveyed for a town site, and shortly thereafter, it was incorporated and named Lucedale. Business in the area was booming, and citizens needed a bank. So in 1903, the Bank of Lucedale was organized, and Luce became the first president.

By about 1910, it became evident that the large number of sawmills in the county were devouring what was once thought to be an inexhaustible supply of virgin timber. Luce liked the people, the climate, and the fertile soil from which the timber was being cut. He marketed tracts of land to home seekers who wished to farm the land. Seeing the success of these farms intrigued him to the point that he established Luce Farms and built a state-of-the-art canning plant for processing vegetables and meat products. The plant employed hundreds of workers displaced from the forest industry and provided a market for increasing numbers of farms. The company cleared over 300 acres of farm and pastureland and introduced new varieties of fruits, vegetables, crops, and livestock for processing and sharing with local farmers. The plant was totally destroyed by fire in 1934 and rebuilt the same year. Much of the Luce farmland was sold to the federal government and deeded to small farmers in 40-acre tracts.

Commerce in Lucedale developed to support the agricultural and forest economy and the welfare of the families. Farm and family supply and grocery stores were complemented by drugstores owned by doctors who moved into town. Main Street had the bank, two hotels, and six automotive dealerships by 1950. Several tractor dealerships replaced the horse and mule business of the Premium Mercantile Company.

Leading businessmen organized the Lucedale Rotary Club in 1937. The club sponsored various cultural events and focused on supporting the agricultural economy. It assisted in organizing a county fair and supported vocational agriculture teachers in the schools, and county agriculture extension agents.

The Bank of Lucedale, renamed Century Bank in 2003, has been the cornerstone of agriculture and commerce in George County for over 100 years. A bank is a requirement for forming a city and county. Gregory Luce founded the bank and served as president until his death in 1935. Competent officers directed by leading businesses and professional men secured integrity and trust in the bank. (Courtesy of Century Bank.)

A newspaper is a requirement to form a county. The *George County Times* was founded in 1903 by Lucious Sellers. His son E.G. "Cotton" Sellers and grandson O.G. "Buddy" Sellers continued as owners and editors. The paper has been operated weekly and each copy filed by the Sellers family to this writing. Local news and pictures assure readership. (Courtesy of the *George County Times*.)

The first barn and lake of Luce Farms marked the beginning of a state-of-the-art farming operation on some 400 acres of cutover land. Farmers who planted on small acreages learned the productive value of the land. Gregory Luce started the farming operation to provide employment for his workers as the timber industry waned. (Courtesy of Century Bank.)

Luce Farms built a modern canning facility and produced vegetables that could be stored as winter production, including onions, shown in this large field, and sweet potatoes. Evie Eubanks is the worker. She, like most youth, historically worked along with parents and caring adults on the farms. (Courtesy of Century Bank.)

Smoke from the canning plant is visible at the end of these long rows of onions and oranges. Production of the crops was labor intensive, from preparing the soil, planting, and cultivating to harvesting and canning. (Courtesy of Century Bank.)

VEGETABLE CONTRACT

No. 63 OFFICE OF THE K-C LUMBER CO. Feb 13 1923

I, _A. F. McLeod_, hereby agree to devote the land and furnish everything necessary to plant and cultivate in proper manner _2_ acres land in _Beans_, to be planted with the variety of seeds furnished by The K-C Lumber Co., and cultivated and harvested as directed by the K-C Lumber Co., to be planted _Mar 15 to 25_ 1923, or as near that date as weather conditions will permit, and to keep them well tended and cultivated, and I agree to deliver all the products of the above specified acreage to The K-C Lumber Co. at their Canning Factory near Lucedale, Miss., in fresh, good condition the same day as harvested during _Spring_ Season of 1923.

All to be young and tender, free from defects, to be delivered in hampers or as may be agreed upon.

In consideration of the fulfillment of the above condition The K-C Lumber Co. agrees to furnish all _Bean_ seed at the rate of $ _.16_ per pound, payable from the proceeds of the first _Beans_ delivered, and to pay for the _Beans 2½¢_ per pound, at its Canning Factory near Lucedale, Miss. Settlement to be made bi-monthly.

Deliveries to be made between the hours of 6:30 a. m. and 5 p. m. on each working day of the week except Saturday. Nothing to be delivered on Saturday without permission.

I hereby agree, if by reason of destruction of Cannery by fire or the elements, the Factory is unable to receive all of the products grown, said Factory shall have right to limit the delivery of said acreage.

 A. F. McLeod, Grower.

Witness: Accepted, THE K-C LUMBER CO.

 Per _Stone_

The lumber company contracted with area landowners to produce vegetables for the canning plant. This vegetable contract with Ash McLeod was to produce two acres of beans in 1923 for a delivery price of 2.5¢ per pound. He was advanced the seed cost at 16¢ per pound. (Courtesy of LeBarron McLeod.)

This lumber yard with the swine herd in the foreground tells the story of the shift to farming by K-C Lumber Company. Mr. Clark was the farm manager. (Courtesy of Century Bank.)

J.C. Dorsett's General Merchandise store, on the corner of Main and Mill Streets, was one of the first four merchandise stores in Lucedale. The Premium Mercantile Company, owned by Richmond McKay and W.W. Thomas, moved its huge store from Merrill to Lucedale after the flood of 1916 to become the fourth in the city. The company also operated the horse and mule barn and the mortuary. (Courtesy of the *George County Times*.)

Grady Yonge managed the horse and mule barn for the Premium Mercantile Company from 1928 until it burned down in 1940. "Buck" Green worked in the barn on weekends as a boy and was paid with the privilege of riding a saddle horse around town when he chose. (Courtesy of Jim Yonge.)

The Edwards family, originally from Clark County, Alabama, moved to George County to work as tenants on the farm of Dr. J.C. Dorsett south of Lucedale. They were later able to purchase and farm land in the Agricola and Howell communities. The children are, from left to right, Bobby Jess "Buck" Christian, June Christian, Joan Rouse (daughter of Ruth Edwards Rouse), and Wayne Christian. The men are, from left to right, J.M. "Red" Edwards, Gilmer Edwards, Wilson Christian (husband of Adele Edwards), and Gavin Edwards. (Courtesy of Brenda Yonge.)

Jex Luce became president of the Bank of Lucedale at the death of his father in 1935. He faced hard times due to the Great Depression and the burning of the canning plant. The bank was closed only for the two days declared as bank holidays by the federal government. Luce reorganized K-C Lumber Company into Luce Products and rebuilt the canning plant. He established a board of directors with businesses and professional community leaders to lead the company and agricultural enterprises, including the ill-fated tung oil enterprise. The company financed an eight-page promotional brochure in 1938 featuring pictures, county data, and photographs of Dr. R.F. Ratliff, vice president of the bank since 1918, and Claude Passeau, famed major-league pitcher. (Courtesy of Century Bank.)

Much of the Luce farmland was bought by the federal government and sold to local farmers with a house and a barn. Improved farm equipment and tractors replaced tenant farmers' horse and mule power. Grady Yonge is shown with his son Howard and one of the first two-row John Deere tractors in the county; it replaced two tenant families and four mules. He hired a teenage boy named Greg Davis (not pictured) who Grady Yonge said "wanted to plow the tractor night and day!" (Courtesy of Jim Yonge.)

Ralph Cowart (left) and his employees sold and serviced Farmall tractors and equipment at Cowart Equipment Company. Fordson were the first tractors sold in the county. Farmers love their tractors and brands and proudly wear blue (Ford), green (John Deere), or red (Farmall). (Courtesy of Paul Cowart.)

In 1968, US Department of Agriculture soil conservation agent Jack Mims (left) and Grady Brown inspect a field of arrowleaf clover on the Brown farm. Arrowleaf was bigger than other varieties of clover and suitable for baling. Brown was selected to plant and introduce the clover to George County farmers. Arrowleaf is widely used in the county for hay, grazing, wildlife management, and soil improvement. (Courtesy of Wayne Brown.)

Long-time businessmen Galloway Corley (left) and J.O. Buchanan operated a plug mill near Lucedale. They also farmed together and are shown in 1960 with some of their prize Herefords. Buchanan owned a hardware store, and Corley later operated a feed mill in Lucedale. (Courtesy of George McDavid.)

Vocational agriculture teachers led by J.V. Gamage worked with the board of supervisors and fair board in 1965 to build a barn at the community center and establish a feeder pig sale. Pigs were sold to larger-market hog producers. Ellis Hodges (pictured) became one of the leading producers in the county. (Courtesy of George McDavid.)

Jack Peters shows his grand champion Guernsey heifer from his father's dairy herd at the Gulf States Fair in Mobile in 1961. Peters later established Jack's Hardware in Lucedale with his wife, Marsha. (Courtesy of Mississippi State University Extension–George County.)

Douglas Luce Jr. (left) is shown with the champion lamb purchased from Rudolph Hall (right) at the George County Livestock Show in 1972. Douglas was the fourth generation of Luces to serve as president of the Bank of Lucedale. The bank became a regional server and changed the name to Century Bank under his leadership at the 2003 celebration of 100 years of financial service. (Courtesy of Mississippi State University Extension–George County.)

Twins Van (left) and Dean Stringfellow show their champion Holstein heifers at the George County Fair in 1980. Van manages the family farm at this writing, and Dean is a veterinarian in the county. (Courtesy of Mississippi State University Extension–George County.)

"Dub" Havard proudly represents the family farm started by his father Lee Havard and later managed by Dub and his brother Harley. The Havards marketed part of their beef and pork through their family-owned grocery store in Lucedale. The farm is still in operation by family members at this writing. (Courtesy of Century Bank.)

David Courtney was an innovator in vegetable production in George County. He represented George County in the Mississippi Farm Bureau and method demonstrations for the Mississippi State University Extension Service. He is shown being interviewed in 1986 for the *Farm Week* television show of the extension service. (Courtesy of Mississippi State University Extension–George County.)

Lee Howell is remembered as one of George County's outstanding nurserymen and a church and community leader. He expanded Rocky Creek Nursery, formed by his father, and was a founder of the George County Nursery Association. (Courtesy of Mississippi State University Extension–George County.)

Carey Johnson, former county extension agent, promoted George County as the "Nursery Capital of Mississippi" in the 1980s. He is shown (left) in discussion with nursery leaders (from left to right) Jeff Howell, Ray Dean, and Jill and Glenn Reed. (Courtesy of Mississippi State University Extension–George County.)

George McNeil became the George County agent for the Mississippi Cooperative Extension Service in 1971. He worked with the local Jaycee chapter to build facilities and revive the George County Fair and helped organize the Lucedale Area Livestock Marketing Association to build facilities and revise the livestock sale. McNeil persuaded Moley Herring to move to Lucedale and serve as manager and auctioneer for the sale. He was appointed area extension vegetable marketing specialist in 1987 and retired in 1990. He then served as director of the George County Economic Development Foundation until his untimely death in 1990. (Courtesy of Faye McNeil.)

An Aeromotor windmill with a decaying wooden water storage tank stands as a relic in George County. These unique, sturdy machines used wind power to pump water to homes, farms, and businesses all over the country until the advent of electric power lines, which furnished a more reliable source of power. Individual electric water pumps replaced the windmills, and rural water systems replaced the electric water pumps. (Courtesy of Jan Hilbun.)

The business districts in most county seat towns circle the courthouse. Main Street in Lucedale was formed on Highway 98 through town, with the courthouse one street south. All the business buildings shown here burned. (Courtesy of John Sims Studio.)

Lucedale Auto, the local Ford dealership, was an early point of great interest, boasting, "we can order you a car, a truck, or a tractor!" (Courtesy of John Sims Studio.)

77

Fires have had devastating effects on Main Street. Four businesses on the corner of Mill and Main Streets burned in 1970. Earlier, the Gregory Hotel and the Premium Mercantile and mule barn burned. The heart pine building materials can explode when on fire and are almost impossible to put out. Pictured here is fire consuming the Coffee Pot restaurant. (Courtesy of John Sims Studio.)

Iness Steede (right) poses with "her butchers," Ralph Howell (left) and Mac Fallon, in Neal's Dry Goods and Grocery. Like many county residents, Steede commuted to work in Mobile for additional family income. Two of her grandsons, Mike and Heath Steede, received degrees in agriculture and served as George County extension agents. (Courtesy of George McDavid.)

Benny's Café was built on East Main Street by Claude Passeau in 1950 and featured a private dining room for community events. It was classic 1950s, with rock and roll on the juke box, hamburgers, and milkshakes. (Courtesy of George McDavid.)

McLeod's shoe store provided quality footwear and repair in Lucedale for over 60 years. Owner Cecil McLeod was deaf from a childhood illness. He communicated with an engaging personality, along with unique hand signs and facial expressions. Doing business with him was a unique and enjoyable experience that resulted in numerous personal stories by his customers. He invented a pocket knife with an aluminum handle and stainless steel blades that would become a collectable with an ever-increasing value. (Courtesy of LeBarron McLeod.)

Six

MEDICINE IN GEORGE COUNTY

Early physicians in the George County area traveled on horseback or by buggy from outside the area. Notices would be posted of the physician's schedule, giving locations and dates when patients could find care. The physician would also make house calls as necessary for patients who were unable to travel. Dr. Sam Poole, whose office was in Leakesville, Mississippi, is the first known physician to make house calls in the area that is now George County. The first physician to reside in the area was Dr. T.H. Moody, who practiced in the Cross Roads community in the late 1880s.

When Lucedale incorporated in 1901, the thriving new town drew a number of physicians. Dr. William D. Ratliff, who earlier had an office in Basin, and Dr. Ford Ratliff, came in 1901. Dr. James Dorsett arrived in 1905, and Dr. John Horn arrived in 1912. Dr. Amon McMillan came to Lucedale in 1918, and Dr. Jack Spiceland arrived in 1924.

The federal Hill-Burton Act paved the way for George County to open a hospital in 1950. George County recorded total expenditures of $272,215 of federal, state, and county funds to buy the property and build the hospital. The facility was equipped for child delivery, surgery, laboratory services, x-ray, emergency room services, and standard medical care matching the level of care in the nearby cities.

The 1940s, 1950s, and 1960s saw an influx of highly trained physicians with the arrival of Dr. Littleton Eubanks, Dr. Victory Landry, Dr. Daniel Gonzales, Dr. Raymond Tipton, Dr. Dayton Whites, and Dr. Thomas Shaw. These physicians were attracted to George County by its past history of good medical care, the rural setting, a sense of family, a mild climate, and a modern hospital that offered services not readily available in other rural areas.

Doctors in George County have led economic and community development in addition to personalized medical care. They have provided drug and merchandise stores, farmed, and served in elected and volunteer positions of influence for citizens of the county and area.

George County elected officials and citizens like Donald Vincent, who chaired the hospital board for years, other board members, and the ever-present Hospital Auxiliary make patients feel cared for with love.

Dr. Sam Poole opened his practice in Leakesville in 1882 and practiced in the area for over 50 years. Most patients were seen at or near their home. Dr. Poole conducted most of his practice by horse and buggy in Greene and George Counties and northwestern Mobile County. He made regular visits to Littleton Eubanks's parents' home and influenced the bright young man to become a physician. (Courtesy of Patricia Bond.)

These arrowheads are from Dr. Poole's collection, found as he rode the area to serve patients. His son Sam Jr. said that as a six-year-old child he remembers his father bringing newly found arrowheads and placing them in the Indian basket in this picture. (Courtesy of Dayton Whites.)

Dr. Ford Ratliff joined his brother Warren in 1901 to practice in Lucedale. He practiced medicine and conduced business on his farm and served on the board of directors of the Bank of Lucedale. He was considered the father of the Lucedale Rotary Club and was very involved in area politics. He allowed some family members to pay their doctor bills by doing timely work on his farm. (Courtesy of Josie Ratliff Henderson.)

This was the first office building of Dr. Warren Ratliff and Dr. Ford Ratliff. The building contained a drugstore and was located on Main Street in Lucedale. Although the sign on the front reads "Cash Drug Store," most medical visits actually did not require payment. (Courtesy of Josie Ratliff Henderson.)

Dr. James Dorsett and family enjoy a ride in one of the first automobiles in George County. Dr. Dorsett received his medical license in 1901 after serving a medical preceptorship with Dr. Sam Poole in Leakesville. Dr. Dorsett was not only a good physician but was also very active in the development of Lucedale and George County. (Courtesy of Jack Huff.)

This building was constructed by Dr. James Dorsett, and the lower floor housed the Lucedale Drug Company and doctors' offices. The upper floor housed doctors, a dentist, and lawyers through the years. At construction in 1917, it was considered the most beautiful building in downtown Lucedale. It remains in use for business and residence today and retains its beauty and historical status. (Courtesy of John Sims Studio.)

Dr. John Horn came to Lucedale in 1913, leaving his practice in Jasper County, Mississippi. His office was in the rear of the Main Drug Company. Dr. Amon McMillan and he worked together for more than 40 years. He did minor surgery, office practice, house calls, and home deliveries. (Courtesy of Buddy and Patsy Horn.)

Curtis E. Miller came to Lucedale from Lumberton, Mississippi, after he graduated from Mississippi College, where he was a hall-of-fame athlete. He was a community health inspector employed by the Mississippi State Board of Health. He is remembered most as a referee for high school and college football. He helped organize the little league and was a model of fitness and health. (Courtesy of Tom and Sissy Bailey.)

Dr. Powell Smith opened his dental practice in Lucedale in 1947. His office was next door to the bowling alley, then in the Western auto building, and finally in the Skinner house on Mill Street. Dr. Latroy Cooley was reared in George County and became a dentist in Lucedale. (Courtesy of Alice Summers.)

Dr. Harold Parker came to Lucedale from Poplarville, Mississippi, in 1932. He opened his dental office in the rear of Ratliff drugstore on Main Street and later relocated to Manila Street. He practiced full time for more than 50 years and for several years part-time. (Courtesy of Hubie and Patsy Parker.)

William Edwin "Edd" Bounds became the first full-time pharmacist in Lucedale in 1959. Edd and his brother Earl purchased the Main Drug store, and Earl later moved it into the Whites-Shaw Clinic. Homegrown pharmacists who have served in Lucedale include Jim Dorsett, Joe Taylor, Larry Woozencraft, Al Eubanks, Jim Busby, Mike Nyman, Butch Dressler, Pat Busby, and Mike Hunter. (Courtesy of Amy Bounds.)

George County health care has benefitted greatly from the service of Keith and Laverne Scott. Laverne served as operating room supervisor at George Regional Hospital for 40 years, from 1962 to 2002. Keith managed the anesthesia department during the same period. He also served as hospital administrator for several years. He influenced the construction of the east wing of George Regional Hospital. Their children are Dr. Tara Mallet, a pediatrician; Dr. Seth Scott and Dr. Heath Scott, family physicians; and Dr. Paul Scott, a urologist. Their sons Derek and Rhett are anesthetists, and Mark Scott is a registered nurse. (Courtesy of the Scott family.)

George County physicians attending the June 1965 Mississippi State Medical Association meeting are, from left to right, Dr. Dayton and Susanne Whites, Dr. Victor and Alice Landry, and Martha and Dr. Daniel Gonzales. Dr. Landry served on the board of directors for the Mississippi State Medical Association in 1965. Dr. Whites served on the George County School Board and was twice elected mayor of Lucedale. (Courtesy of Dayton Whites.)

David Schultz opened his practice as a chiropractor in Lucedale on February 21, 1982. His office is on Winter Street. Dr. Schultz is a very personal physician and is well respected in his profession. He is a community and church leader. Earlier Lucedale chiropractors were Dr. Richard Richie, Dr. Robert Johnson, and Dr. Dewey Herrington. (Courtesy of Mary Schultz.)

George Regional Hospital medical staff are pictured in 1990. From left to right are Dr. Raymond Tipton, general practitioner; Dr. Thomas Shaw, family physician; Dr. Dayton Whites, family physician; Dr. Daniel Gonzales, surgeon and general practitioner; and Dr. Chintamaneni Suresh, general surgeon. Not pictured are Dr. Victor Landry, surgeon and general practitioner, and Dr. William Bennett, internist. (Courtesy of Dayton Whites.)

Joyce Horne Rutherford began working in the George Regional Hospital laboratory in May 1973. In 1975, she became head of the department. During her tenure, the laboratory advanced from doing less than 20 in-house lab procedures to over 100 per day. She retired in October 2015 after 43 years of service to the hospital. (Courtesy of George Regional Hospital.)

The Louis Valentine family contributed much to George County in the medical and business community. Pictured with Louis are his four girls. From left to right are Stacy Valentine, chief executive officer at Wiggly and Culp Inc.; Dr. Ashley Valentine Macarthur, dentist; Dr. Courtney Valentine, family physician; and Dr. Leslie Valentine, ophthalmologist. In his 25th year, Louis is the longest serving member in the history of the Lucedale Board of Aldermen. (Courtesy of Louis Valentine.)

George Regional Hospital Outpatient Services was opened in 2001. This was an advancement for George Regional Hospital, in that those seeking outpatient procedures, including surgery, could be handled with greater convenience for both patients and hospital employees. (Courtesy of Joyce Rutherford.)

Seven

LAW AND GOVERNMENT

The Jackson County Courthouse, in the Old Americus community of Jackson County, was burned down in October 1837, allegedly by the notorious Copeland Gang. This left the area with very limited government service. Development of the forest industry, along with the marketing of turpentine and building of railroads, opened up the lands between the rivers to logging. This provided the capital for economic and community development.

The incorporation of Lucedale in 1901 provided the legal and ethical means to invest in capital improvements, build the labor force, and develop the abundant land and water resources through agricultural enterprises of the county.

The first mayor of the town was Dr. W.B. Brewton, who provided the office and meeting space for the town council in his business establishment. The Bank of Lucedale, doctors' offices, and the newspaper were the centers of business and influence in Lucedale.

George County was established by the Mississippi legislature in 1910, which brought the full services of the state and federal government to the area. The county elected a board of supervisors who moved toward establishing a county seat and building a courthouse. Dr. Brewton again provided temporary office space in his building.

Lucedale was chosen as the county seat by a narrow margin of votes over the river community of Merrill. Merrill had a population of over 2,000, and Lucedale had less than 800, according to the 1910 census. Lucedale had the influence of larger employers and relationships with church and community leaders.

The board of supervisors appointed Charles Eubanks as the first sheriff of the county. Murdock Roberts was the first elected sheriff in 1911. Civil order was influenced by active churches and community leaders and a competent legal system of lawyers and judges.

George County has had two sheriffs killed in the line of duty. Sheriff John Nelson was killed in a domestic violence case on December 21, 1948. Sheriff Garry Welford was killed while attempting an arrest on July 21, 2011. These tragedies heightened the awareness among the citizenry of the importance of a professional law enforcement system.

Dr. W.B. Brewton, the first mayor of Lucedale, constructed this building to house his drugstore and medical office. According to the first ordinance passed by the town in 1901, the meeting place of the board of aldermen would be in the T.R. James law office in this building. In 1910, when George County was incorporated, the building housed the legal officers, files, and meetings while the courthouse was being built. (Courtesy of Carol Brewton Forney.)

Dr. W.B. Brewton made his way to Lucedale from Brewton, Alabama, a city named to honor his uncle Edmond Troupe Brewton, its founder. Dr. Brewton had just received his degree in medicine and surgery from the Medical College of Alabama on April 6, 1900. He served as the first mayor of Lucedale for one term and then as a member of the board of aldermen. (Courtesy of Carol Brewton Forney.)

George County chancery clerk Carl Havard poses in 1971 to illustrate the need for expansion of the courthouse. A federal grant had been secured to pay for a modern concrete courthouse and removal of the old, crowded, outdated courthouse. Concerned citizens led by Carol Nelson Murphy were successful in blocking the destruction of the beautiful old courthouse. County leaders built an addition to the old courthouse in 1975. (Courtesy of George McDavid.)

This 1860 jail, designed for delivery by rail, was purchased for service in Merrill. It was built into the original George County Courthouse and torn out when the courthouse and jail were remodeled in 1976. It was generously restored to original form by American Tank and Vessel Company, delivered to Lucedale Municipal Park, and placed next to the old County Line School, a monument to the value of education. (Courtesy of Jim Yonge.)

Lucedale enjoys a modern city hall. Lola Hunter became city clerk in 1955 and retired in 1981. She saw the town of Lucedale develop into the city of Lucedale, with a population of 2,000. She recalled that in 1955, the city hall was located in one small room with a manual typewriter, an adding machine, one filing cabinet, a few chairs, and two small tables. (Courtesy of Jim Yonge.)

Eugene Howell, who served as sheriff of George County for 24 years (1964–1967 and 1976–1995), is pictured in 1964 with his family. From left to right are Andy, Sheriff Howell, Janice, Karen, Josephine, and Debra. (Courtesy of George McDavid.)

Lucedale officials have a legacy of positive relations with state and federal officials. In 1976, from left to right, Lucedale mayor Al Rouse visits with Mississippi governor Cliff Finch (1976–1980), Wash Butler, chief of police Mendell Waschman, and Ricky Aldredge. (Courtesy of George McDavid.)

Milton Murrah (right), civil defense director of Lucedale and George County, is seen giving radio information to an associate in 1968. Milton distinguished himself as an untiring community servant. The city sports complex is named in his honor. (Courtesy of George McDavid.)

Grace Wilkerson, postmaster of the Benndale Post Office, leaves the office in 1967 after 27 years of service as postmaster and proprietor of the country store. Her son Connie wrote letters home from college simply addressed "Momma, Benndale, Mississippi." Each letter found its way to momma at the Benndale Post Office. (Courtesy of Connie Wilkerson.)

Albert G. Dickerson and his wife, Addie, served together as postmaster of the Bexley community beginning in 1921. By 1956, most of the local post offices had consolidated with Lucedale and took advantage of Rural Free Delivery, or RFD. (Courtesy of George McDavid.)

Pictured is the 1928 George County Board of Supervisors. From left to right are (seated) Floren Maples, James Howell, Print Byrd, Charlie Bennett, and Charles Posey Eubanks; (standing) chancery clerk Maurice Leander Malone, county attorney O.F. Moss, superintendent of education Leonard Adams, Sheriff Joe Catlett, and tax assessor T.W. Persons. (Courtesy of Mark Maples.)

George County attorneys, some with their spouses, attend the 1964–1965 state bar convention. Seated from left to right are W.S. Murphy, Malcolm Murphy, Darryl A. Hurt, Mary Frances Hurt, Darwin M. Maples, Minnie Ellen Maples, Esther Moss, and Owen Moss. (Courtesy of Mark Maples.)

After ratification of the 19th Amendment to the US Constitution in 1920, Virginia Young Moss, wife of attorney O.F. Moss, was the first woman to register to vote in George County. She was also an accomplished artist known for her paintings of magnolias and camellias. (Courtesy of the City of Lucedale.)

Sarah Edith Ivory, a native and resident of the Shipman community, was noted for paying poll taxes in the 1940s and 1950s even though she was not allowed to vote. People were required to take a test administered by the circuit clerk and pay $2 to vote. Ivory said, "I pay poll taxes because a portion of the taxes go to education, and I believe in education." (Courtesy of Doris Alexander.)

Eight
ATHLETICS

Like most rural counties in Mississippi, sports teams and athletic events have been important parts of recreation for George County residents. Much of this centered around the local schools and their athletic teams. For most of the 1930s through the 1950s, there were five high schools in George County: Lucedale, Rocky Creek, Agricola, Basin, and Broome. All schools fielded boys' and girls' basketball teams and, at various times, softball teams. For most of this period, Lucedale High School was the only school to have football teams, but both Rocky Creek and Agricola did have teams from 1958 to 1964.

Over the years, George County has produced many outstanding athletes in all of the major sports, but three are truly exceptional. Claude Passeau was one of the best major-league pitchers during the late 1930s and 1940s and pitched a one-hit game during the 1945 World Series. Eric Moulds was a star football player at Mississippi State and an NFL first-round draft pick in 1996. He played a total of 12 seasons for the Buffalo Bills, Houston Texans, and Tennessee Titans and was selected to the Pro Bowl three times.

There is no doubt that Janice Lawrence is the most outstanding female basketball player George County has produced. After high school, she played college basketball for Louisiana Tech University, where she was voted All-American in 1983 and 1984 and led her team to national championships in 1981 and 1982. She received numerous awards during her career, including an Olympic gold medal in 1984.

There have been many outstanding high school sports teams in George County, but two teams are especially revered. The Agricola girls' basketball team of 1955 was truly a Cinderella team. From a high school with a small student body, this team went on to win the state championship, competing against larger schools.

The Lucedale High School football team of 1953 was one of the best in the state and outstanding considering the size of the school's enrollment. The team went undefeated throughout the season. The next year, four members of this team signed scholarships with Southeastern Conference (SEC) universities.

In the 1930s and 1940s, baseball was America's favorite sport, and Claude Passeau was George County's favorite player. Passeau attended Millsaps College, where he was a four-sport star. He went on to play 13 years in the major leagues as an outstanding pitcher. He won 162 games, played in five all-star games, was a 20-game winner in 1940, strikeout leader in 1939, and had a lifetime earned run average of 3.32. But he is best known for pitching a one-hit game for the Chicago Cubs in the 1945 World Series against the Detroit Tigers. Passeau was a local John Deere dealer and served two terms as sheriff of George County. (Courtesy of Claude Passeau Jr.)

Janice Lawrence played for George County High School from 1977 to 1980 and was among the state's most recruited players in 1980. She accepted a scholarship with Louisiana Tech, a perennial girls' basketball power that won national championships in 1981 and 1982. While a sophomore, she was the leading scorer in the NCAA tournament and was the tournament's MVP. In 1984, she was named Women's College Basketball Player of the Year. That same year, she won gold at the Olympics with the USA women's basketball team. She played 13 years in the Italian Professional League and won four European championships. She also played two seasons for the WNBA's Cleveland Rockets. Lawrence was inducted into the Louisiana Tech Hall of Fame in 1987 and the Women's National Basketball Hall of Fame in 2006. (Courtesy of John Sims Studio.)

The 1955 Agricola girls' basketball team was a Cinderella story that won the statewide championship and 86 consecutive games during the 1955 and 1956 seasons, still a state record. The team included, from left to right, (first row) Shirley Holland, Betty Gunter, Patsy Young, Vera Bush, Carol Upton, Paula Wall, and Betty Tanner; (second row) Ruth Brown, June Gunter, Margie Holland, Frances Cooley, Rachel Bufkin, Kay Jones, Jessie Bush, and coach James Wiginton. (Courtesy of Kay Christian.)

Jimmy Havard was a star running back for Lucedale High School from 1953 to 1957. He was the son of Carl and Virginia Havard of the Central community. Carl served as chancery clerk for George County. In 1957, Jimmy was selected Outstanding Running Back in the DeSoto Conference and played in the Mississippi All-Star Game. After graduation, he signed a scholarship to play at the University of Southern Mississippi. Havard was a star running back at Southern and lettered for three years. While serving in the US Army after graduation, he played for the Fort Benning football team that won the National Service Championship in 1964. He was inducted into the University of Southern Mississippi Sports Hall of Fame in 1981 and is also well known for his many years of service as chancery clerk for Forest County. (Courtesy of Jimmy Havard.)

The 1953 Lucedale High School football team went undefeated, and the defense only allowed 27 points all season. Teammates from the 1953 squad went on to distinguished careers. Benton and Glen Roy Hilbun became medical doctors. Warren Neal became dean of the University of Tennessee School of Business. Wayne Brown served as highway commissioner, and Henry Bradshaw became vice president of the Armstrong Corporation. Tommy Bailey flew for the Air Force and as a commercial pilot. Lester Hatcher was also an Air Force pilot. (Courtesy of Bruce Fryfogle.)

Leemon McHenry played for Lucedale High School from 1948 to 1950. He was recognized as one of the best passers in Mississippi in his senior season. After graduation, McHenry signed a scholarship with Southern Mississippi and played four years for coach Pie Vann. After graduation, he had a distinguished military career as a Marine officer, serving two tours in Vietnam and retiring with the rank of colonel. (Courtesy of Joyce McHenry.)

Four players from the 1954 Lucedale High School football team signed scholarships with SEC colleges. Seated from left to right, Jimmy Deakle and Bruce Fryfogle went to Tennessee, and Hanson "Bull" Churchwell and Dick Woodard went to the University of Mississippi. Churchwell starred at Ole Miss as an offensive tackle and was drafted in the fifth round in 1959, playing for the Washington Redskins and Oakland Raiders. Standing are J.P. Pouncey and Taylor "Tick" Tatum. (Courtesy of Bruce Fryfogle.)

Harmon "Bull" Brannon played football at Rocky Creek High School from 1959 to 1961. Coach P.W. Underwood's team lost only three games during this period, and Harmon was the team's star running back. After graduation, he signed a scholarship with Southern Mississippi and was an outstanding running back for four years before being drafted by the Dallas Cowboys. After football, Brannon returned to George County, and he and his wife own a duck and deer hunting business. (Courtesy of Harmon Brannon.)

Julius "Poochie" Stringfellow played at Lucedale High School from 1959 to 1961. In 1961, he was voted Outstanding Lineman in the DeSoto Conference. After graduation, he accepted a scholarship to attend Southern Mississippi. He played nose guard from 1964 to 1966, and signed a professional contract with the Ottawa Rough Riders of the Canadian Football League. After football, Stringfellow returned to George County and served as an assistant coach until he retired. In 1986, he was inducted into the University of Southern Mississippi Sports Hall of Fame, and in 2001, he was listed in the top 100 to ever play football at the school. (Courtesy of Julius "Poochie" Stringfellow.)

Eric Moulds was one of the most talented athletes to attend George County High School. He accepted a scholarship with Mississippi State and played wide receiver from 1993 to 1995. Moulds ranks fourth in yards and third in touchdowns on Mississippi State's receiver list. In 1994, he led the nation in kickoff return yardage. In 1996, he was the Buffalo Bills' first-round draft pick and the 24th overall selection. In 1998, Moulds set a team record for single-season receiving yards with 1,368. In eight seasons in Buffalo, Moulds had 626 receptions for 8,523 yards. He spent 2006 with the Houston Texans and 2007 with the Tennessee Titans. (Courtesy of Angie Cowin.)

The 1976 George County girls' basketball team won the Class AA state championship. The team compiled 34 wins and five losses. Team members are, from left to right, (first row) Nan Breland, Sharon D'Orville, Edna Purvis, Sharon Phillips, Sissy Freeman, Debbie Jones, and Vanessa Polk; (second row:) Steve Miller (scorer), Laura Lawrence (manager), Kathy O'Neal, Jinan Green, Sarah Dickerson, Lisa Courtney, Connie Doty, Karen Fallon, Brenda Sumrall, Becky Howell (statistician), and coach Rudolph Sellers. Sheila Byrd is not pictured. (Courtesy of Rudolph Sellers.)

Rudolph Sellers coached both the boys' and girls' basketball teams at George County High School during a 32-year career. His teams won nine division titles and advanced to the state tournament 14 times. His girls' team won the state AA championship in 1976 and finished in second place in 1979 and 1980. Sellers was selected Coach of the Year (district or division) 12 times. In 1976, he coached the South Girls' All-Star Team in the Mississippi Association of Coaches All-Star Game. Coach Sellers was inducted into the MAC Hall of Fame in 2013. In 2016, he was honored when the George County High School gymnasium was named the Rudolph Sellers Gymnasium. (Courtesy of Rudolph Sellers.)

Fred Gill (left) and Bill Martin (right) coached together for nearly 30 years. Gill came to Lucedale High School in 1960 as an assistant coach. Two years later, he was promoted to head coach, and he hired Bill Martin as an assistant in 1963. Over the years, these men alternated as head coach, but Martin always coached the line and Gill coached the backs and receivers. In 1965, county high schools were consolidated at George County High School, where the duo led the football team. Before districts were formed, George County High School was a member of the DeSoto Conference. During this period, the team was invited to four bowl games and won five conference championships. In 1996, the football stadium was named the Gill Martin Stadium. (Courtesy of Gayle Gill.)

Lucedale High School had football teams during most of the 1930s, but Agricola High School also fielded a team in 1938 and possibly 1939. Research indicates that the team only played two or three games and never recorded a victory. With only 11 players, they had to have given their all. From left to right are (first row) Milton Brown, Dick Hunter, Dennison ?, Oferrel Brown, two unidentified, and Buddy Hathcock; (second row) coach Emmet Westerfield, Dub ?, Roy Dean, Johnny B. Shows, and Benny Wall. (Courtesy of Bennie Shows.)

The last member of this select group of George County athletes, Will Scott, is also the youngest. A place kicker and punter, Scott had an outstanding career at George County High School from 2007 to 2009. He was selected All-Regional in 2008 and 2009 and All-State in 2009. He was also selected to play in the Mississippi-Alabama All-Star Classic and was named the game's MVP. After graduation, he signed to play at Gulf Coast Community College. He had an outstanding career there and in 2010 was named to the National Junior College Athletic Association All-American Team and also to the Academic All-American Team. After graduation from Gulf Coast, Scott signed a scholarship with Troy University, where he continued to excel and was selected to the All–Sun Belt Team as punter/kicker, was a Ray Guy Award semifinalist, and was on the Lou Groza watch list. He graduated magna cum laude in 2014 and, in the tradition of the Keith Scott family, pursued a medical career. (Courtesy of Derrick Scott.)

Nine

MILITARY

The area that is now George County has been the home of many military veterans beginning with the Revolutionary War. Surnames of Revolutionary War veterans from the county include Howell, Goff, King, and Carter. Residents fought in the War of 1812, various Indian engagements, the American Civil War, the Spanish-American War, and the Mexican-American War prior to the formation of the county in 1910.

George County has been generous in support of the military, with young men and women serving in every conflict and in all branches. The Mississippi Department of Archives and History records 290 men who served in World War I. Many were shipped to Europe.

World War II began with George County soldiers serving at Pearl Harbor, including A.C. Hillman, Burnell D. Smith, and Lloyd E. Yonge, all of whom survived the war. Hundreds of George County men and women served during this protracted war, and many performed illustrious service. Jake Lindsey from the county was the 100th person to receive the Medal of Honor during World War II. Others received the Silver Star and Purple Heart, among other locally awarded medals. Over 30 military men from the county died in the war.

The Korean War once again called upon George County men and women to battle in foreign lands. This terrible engagement was followed by the Vietnam War, which also inflicted much death, pain, loneliness, separation, injury, and lingering combat-related mental health issues.

George County has had an active National Guard since World War II that has been activated and deployed four times. The unit was deployed to Germany during the Korean War, to Iraq during Desert Storm and again during Operation Iraqi Freedom, and to Afghanistan from 2010 to 2011. Four men were lost in these engagements.

George County is home to an active American Legion and Auxiliary post. The post recognizes Veterans Day with a ceremony and lunch followed by a parade through the city of Lucedale.

"IN REMEMBERANCE OF THOSE WHO GAVE ALL"

WORLD WAR I

JAMES H GRANTHAM RAY T HOWELL

WORLD WAR II

PALMER ALLMAN	WILLIAM S BEXLEY
ROBERT L BLACKSTON	DAN W CARTER
JOSEPH L DUKE JR	JESSE T DUNCAN
JOHN M EUBANKS	JACK K GIBSON
LEE G GRAVES	BERCHART K GUNTER
ELBERT A HAVARD	WALTER D HAVARD
JAMES B HINSON	ALVIN D HOLLAND
ALTON HOWELL	DANIAL HOWELL
WYATT C HYATT	CECIL G LAMBERT
ELERIE LUDGOOD	WILLIAM B McLAIN
LIONEL T McLEMORE	LYMAN MILLER
JAMES A MOORE	WILLIAM G MOORE
HEWEY H PURVIS	IRA J REEVES
LEONARD C ROBERTS	JAMES C SLAY
WILLIAM M SMITH	RUBLE J SOLOMON

KOREA

DAVID L BEARD	WILLIAM C HEMBREE
AMON K SMITH	ROSCOE WOODARD

VIETNAM

CARL M EUBANKS	ADRIAN E HOWELL
WILLIAM E HOWELL	AVON N MALLETTE

WARREN L WOZENCRAFT

MEDAL OF HONOR WINNER
Tsgt JAKE W LINDSEY

This war memorial is located on Manilla Street off Courthouse Square in Lucedale. It lists all of the men from George County who were killed in World Wars I and II, Korea, and Vietnam. Sean Cooley, killed in Operation Iraqi Freedom, and Robert McNial, Larry Arnold, and Terrance D. Lee, killed in support of Operation Iraqi Freedom, are pictured on a monument at the National Guard armory in Lucedale. (Courtesy of Jim Yonge.)

Jake Lindsey joined the army in Lucedale in 1940. He was nicknamed the "one man army" and awarded 16 medals for his World War II and Korean War exploits. He was the only person to receive the Medal of Honor before a joint session of the US Congress from Pres. Harry S. Truman. He was honored for repelling a German counterattack in Germany on November 16, 1944. In the Korean War, Lindsey was given a battlefield commission, which he resigned to take master sergeant stripes so he could serve in the ranks. He is pictured showing his sergeant blouse over the second lieutenant jacket. (Courtesy of Wayne Brown.)

Alderson C. Hillman joined the Marine Corps in May 1940. He was assigned to the battleship USS *California* and sailed to Pearl Harbor. During the Japanese attack on the US naval base, he manned a machine gun station on his sinking ship until he ran out of ammunition. He was assigned to the aircraft carrier USS *Lexington* in the Pacific campaign against the Japanese, suffering three injuries. He later served in the Army Reserves for 26 years. (Courtesy of Al Hillman.)

Geraldine Horn from George County joined the Army in 1943. She became the personal secretary of Gen. Mark Clark, commander of the Fifth Army, and served in the North African and Italian campaigns in World War II. She was awarded the Bronze Star for meritorious service by General Clark. She served as veterans service officer in George County until her retirement. (Courtesy of Joyce Rutherford.)

Cadet John L. Bryan flew in the Burma-China-India theater during World War II. He "flew the Hump," the dangerous mission over the Himalayas delivering fuel and supplies to the Chinese army of Chiang Kai-Shek. He was a captain at the end of World War II and was recalled during the Korean War. (Courtesy of Patsy Horn.)

Many families had more than one member in the armed services during World War II, including the Browns and Hornes in George County. The first cousins who proudly served include, from left to right, Joe Brown, Thurmond Horne, Gideon Brown, Geraldine Horne, and Robert and Fred Horne. (Courtesy of Patsy Horne.)

Lucedale High School graduates Navy lieutenant commander Ralph Brown (right) and Marine major Leemon McHenry are shown in 1968 on the deck of the USS *Tripoli* in the Gulf of Tonkin during a combat tour in the Vietnam War. At their first meeting, Major McHenry, being older, did not recognize Lieutenant Commander Brown, who then asked, "do you still get the *George County Times?*" (Courtesy of Wayne Brown.)

The George County Draft Board members pictured in 1965 are (from left to right) unidentified, J.F. Averett, Margie Bailey, Curtis Miller, William Freeman, Horace Bradley, Rosalie Green, and William S. Murphy. From 1940 until 1973, men were drafted to fill vacancies in the US armed forces that could not be filled with volunteers. (Courtesy of George McDavid.)

National Guard camp at Camp Shelby was an annual event for members of the National Guard unit. Capt. Dick Hunter led the George County unit, seen above firing artillery and below relaxing in their tents with longtime S.Sgt. Jack Lamb (center) of George County. (Both, courtesy of George McDavid.)

Lester Hatcher flew combat missions during the Vietnam War and retired from the US Air Force. He is pictured with his sons Trent and Ken and daughter-in-law Gloria, who were all Air Force pilots with the rank of lieutenant colonel before retirement. (Courtesy of Mary Hatcher.)

The George County National Guard was honored with a welcome-home parade on its return from Operation Desert Storm. The members that are identified are, from left to right, Jimmy Mote, Roy Havard, Todd Keys, Larry Odem, and Steen Pipkins. (Courtesy of the *George County Times*.)

Ten

Community Enrichment

The many threads of human endeavor weave together to form the tapestry of community, and George County's is rich and vibrant. It begins with a warm climate that provides year-round outdoor activity. The Pascagoula and Escatawpa Rivers, early transportation routes, now provide recreation and are enhanced by private forests as well as Nature Conservancy property and the Pascagoula River Wildlife Management Area. Outdoor opportunities also abound in Lucedale's parks, ball fields, and the nature trails of the Greenway.

In the 1920s and 1930s, automobiles lessened isolation on the county farms and permitted the birth of social self-improvement groups. Nineteen home demonstration clubs were active, and favorite programs included food preservation and family clothing. Eleven 4-H clubs taught agriculture skills to youths during this time. Later, the local Boy Scouts and Girl Scouts programs were organized. Both teach personal and civic responsibility to youths and provide wholesome and educational activities.

In 1928, the Business Girls' Club began with a strong emphasis on civic improvement, and was instrumental in constructing a bandstand gazebo, providing park lighting, and building a clubhouse, which now houses the chamber of commerce. Regular Saturday performances and social events attracted residents to the bandstand. In 1934, thanks to the local Women's Club, a one-room public library opened. That library grew to become a communication hub with print and electronic media, classes, and activities for all ages.

Shakespeare in the Park began as a special National Library Week event in the spring of 1991 and lasted until 2011. The spring festival attracted thousands and became known as Mississippi Shakespeare in the Park. Since 2013, Praise in the Park has attracted thousands annually to hear national contemporary Christian artists.

In 1935, the Lucedale Rotary Club was formed. Its first project was to establish dipping vats to protect cattle from insects and parasites, although the club is now more popularly revered for annually sponsoring the county fair and the Christmas parade. The George County Economic Development Foundation was formed in the 1950s, and its primary project was the development of the industrial park.

George County is part of the Pascagoula River Wildlife Management Area, comprised of nearly 37,000 acres of pristine bottomland on the Pascagoula River. It is a protected wilderness area and a major bird migration flyway. Its forests are home to whitetail deer, wild hogs, squirrels, turkeys, ducks, owls, herons, songbirds, turtles, snakes, and alligators. The county's many lakes, creeks, and rivers provide ample recreational fishing opportunities, as illustrated by the catch pictured here. Some species include largemouth bass, bluegill, catfish, crappie, shellcracker, and sunfish. During the hard times of the Great Depression, the diets of many George County families were supplemented from the bounty of its waters. Fish fry gatherings by families or groups were summer social events for many years. (Courtesy of Jim Yonge.)

The Mississippi Department of Wildlife, Fisheries, and Parks Recreational Trails provided funding to design and construct an educational pavilion that would be a reflection of Lucedale's train depot. Some of the amenities of the Depot Creek Greenway include handicapped-accessible wooded walkways with nature trails visited by fowl and furry friends alike that link to trails in the Lucedale Municipal Park and the Lucedale Preserve. (Courtesy of Dayton Whites.)

Alvita Kemp, Highlight 4-H volunteer, helps former extension agent Carey Johnson prepare for the annual George County 4-H awards program. The 4-H program teaches children and youth achievement, citizenship, and leadership. The four Hs stand for Head, Heart, Hands, and Health, representing academic and spiritual values for youth development. (Courtesy of Mississippi State University Extension–George County.)

George County 4-H members participated in the Southeast District contest in the Jones community in 1962. Participants were, from left to right, (first row) Janette Havens, Diane Pool, and Martha Byrd; (second row) Kendell Stringfellow and Larry Williamson; (third row) Ronnie Miller and Carolyn Carpenter, the George County 4-H extension agent. The 4-H pledge is inscribed on the plaque. (Courtesy of Mississippi State University Extension–George County.)

The George County Fair has included livestock shows and sales, along with home, garden, and 4-H exhibits, since the 1930s. The fair was revived in 1972 by the local Jaycees and moved to the fair grounds on old Highway 63. The Lucedale Rotary sponsors the fair in cooperation with the Mississippi Cooperative Extension Service. (Courtesy of Mississippi State University Extension–George County.)

The Boy Scouts of America celebrated its 50th anniversary in 1960 with special activities across the country to show what Scouting had done. Lucedale Troop 25 Scouts and Explorer Scouts were combined with Wiggins's troop to form Pine Burr Area Troop 77 for the Fifth Annual Boy Scout Jamboree in Colorado Springs, Colorado. The theme of the jamboree was For God and Country. (Courtesy of Richmond McKay.)

Tim Dudley Sr. pins George Taylor, SRE chief engineer, with the Silver Beaver Medal and Knot for distinguished service to Scouting. To receive the award, one must be an adult leader who impacts the lives of youths, implements the Scouting program, and performs community service through hard work, self-sacrifice, dedication, and many years of service. (Courtesy of George McDavid.)

Alma Lumpkin, known as the "Library Woman," served as librarian for 31 years until she retired on January 1, 1970. She guided the library from a WPA project in the 1930s to a regional library with Jackson County. The sculpture at the entrance to the Lucedale–George County Public Library was sculpted and donated by Jimmy Corley in April 2003. Corley was inspired by memories of his grandmother Alma Lumpkin reading during Story Time. Janet Smith guided the library's growth from 1971 until her retirement in 2005. (Courtesy of George McDavid.)

Chair Cecelia "Cissy" Cochran (right) and co-chair Audra Gail Rouse announce the Gingham Tree Arts and Crafts Festival, which has been wooing early Christmas shoppers since its beginning in the fall of 1972. Traditionally held on the second Saturday of November and sponsored by the Lucedale Fine Arts Club, the festival has been hosted in Lucedale Municipal Park and George County High School (now George County Middle School). It was relocated to the fairgrounds in 2017. (Courtesy of Lucedale City Hall.)

The Lucedale Rotary Club organized the annual Christmas parade in cooperation with the City of Lucedale in 1958. Residents from churches, boys' and girls' clubs, and local bands and businesses came together to celebrate the Christmas season. This float is traveling on Main Street in front of the Super 5&10 store on a chilly afternoon. (Courtesy of George McDavid.)

Lucedale Jaycees revived the Christmas parade in 1970. George County Middle School and High School bands have contributed to the parade and the enjoyment of the crowd. Shown here is the Lucedale Middle School band marching on Main Street just beyond the First United Methodist Church. (Courtesy of the *George County Times*.)

125

The Rotary Club again took sponsorship of the Christmas parade in 1990 and made it a night event. The parade now exceeds over 100 entries, with crowds estimated to be over 10,000. The parade is about 1.25 miles in length. It is the highlight of the evening when Santa Claus comes to town with local children serving as his elves, shown here arriving after the floats on an antique 1941 International Harvester fire truck that is literally fire-engine red. Up to 300 horses from area states end the parade each year following Saint Nick throwing candy from the fire truck. (Courtesy of John Sims Studio.)

The Veterans Memorial in Lucedale Municipal Park was designed by Jimmy Corley and built locally by city and local business employees. The plaque in the ground-level brickwork honors all veterans and is fully illuminated by the sun only one day of the year. Sunlight passes through the tiered circles without obstruction at the 11th hour of the 11th day of the 11th month. (Courtesy of Jim Yonge.)

Clyde Dungan (left), educator and weekend barber, and Luther Jones confer about a March of Dimes fundraising campaign. George Countians have a legacy of generous giving to national fundraising campaigns, including St. Jude Children's Hospital, American Heart Association, Relay for Life, Habitat for Humanity, and church construction, among others. A center for nonprofits includes the Salvation Army, Habitat for Humanity, and Alcoholics Anonymous. (Courtesy of George McDavid.)

The Tree City Committee, aldermen, chief of police, city clerk, and mayor observe National Arbor Day in 1994. Tree City USA is a community improvement project sponsored by the National Arbor Day Foundation in cooperation with the National Association of State Foresters, US Forest Service, US Conference of Mayors, and National League of Cities. As of 2017, Lucedale has been awarded Tree City USA status for 28 years. (Courtesy of Lucedale City Hall.)

Discover Thousands of Local History Books
Featuring Millions of Vintage Images

Arcadia Publishing, the leading local history publisher in the United States, is committed to making history accessible and meaningful through publishing books that celebrate and preserve the heritage of America's people and places.

Find more books like this at
www.arcadiapublishing.com

Search for your hometown history, your old stomping grounds, and even your favorite sports team.

Consistent with our mission to preserve history on a local level, this book was printed in South Carolina on American-made paper and manufactured entirely in the United States. Products carrying the accredited Forest Stewardship Council (FSC) label are printed on 100 percent FSC-certified paper.

MADE IN THE USA